Start with Art

People

© Aladdin Books Ltd 1999

Designed and produced by
Aladdin Books Ltd
28 Percy Street
London W1P 0LD

First published in the United States in 1999 by
Copper Beech Books,
an imprint of
The Millbrook Press
2 Old New Milford Road
Brookfield, Connecticut 06804

Project Editor
Sally Hewitt

Editor
Liz White

Design
David West Children's Book Design

Designer
Flick Killerby

Illustrator
Rob Shone

Picture Research
Carlotta Cooper/Brooks Krikler Research

Printed in Belgium
All rights reserved

Library of Congress Cataloging-in-Publication Data
Lacey, Sue.
People / Sue Lacey.
p. cm . – (Start with art)
Summary: Examines different techniques and styles that can be used when drawing
people, including portraits, caricature, collage, and 3-D modeling, using examples
from great artists and suggestions for creating your own works.
ISBN 0-7613-3262-6 (lib. bdg.)
ISBN 0-7613-0829-6 (pbk)
1. Human figure in art Juvenile literature. 2. Drawing – Technique Juvenile
literature. [1. Human figure in art. 2. Drawing – Technique. 3. Art appreciation.]
I. Title. II. Series.
NC765.L26 1999 743.4–dc21 99-35496 CIP

The project editor, Sally Hewitt, is an experienced teacher. She writes and edits books
for children on a wide variety of subjects including art, science, music, and math.

Sue Lacey is an experienced teacher of art. She currently teaches primary school
children in the south of England. In her spare time, she paints and sculpts.

photocredits: Abbreviations: t-top, m-middle, b-bottom, r-right, l-left, c-center
All the pictures in this book are by Vanessa Bailey apart from the following pages:
Cover br, 4b, 17, 21, 25: AKG London; 4t, 11: AKG. © Succession Picasso/DACS 1999; 8-9b, 13, 27, 29:
AKG/Erich Lessing; 14b: Musée Marmottan, Paris; 23: AKG. © DACS 1999; 31:
Courtesy of the October Gallery, Paloma.

Start with Art

People

Sue Lacey

COPPER BEECH BOOKS
BROOKFIELD • CONNECTICUT

INTRODUCTION

Artists work with many different tools and materials to make art. They also spend a lot of time looking carefully at shapes, patterns, and colors in the world around them.

This book is about how artists see **people**. On every page you will find a work of art by a different famous artist, which will give you ideas and inspiration for the project.

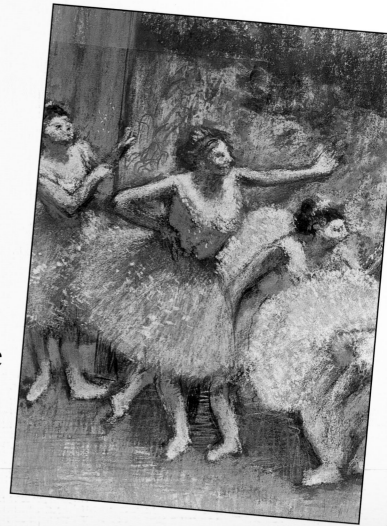

You don't have to be a brilliant artist to do the projects. Look at each piece of art, learn about the artists, and have fun being creative.

CONTENTS

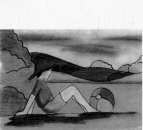

WORKING LIKE AN ARTIST

It can help you in your work if you start by observing carefully and collecting ideas, just like an artist. Artists usually carry a sketchbook around with them all the time so they can put their ideas on paper immediately.

Words
You can take notes to remind you of the shapes, colors, and patterns you see.

Materials
Try different pencils, pens, paints, pastels, crayons, and materials to see what they do. Which would be best for this work?

Color
When you use color, mix all the colors you want first and try them out. It is amazing how many different colors you can make.

Using a sketchbook Before you start each project, this is the place to put your sketches. Try out your tools and materials, mix colors, and put in interesting papers and fabrics. You can then choose which ones you want to use.

Be a magpie

Make a collection of things that interest you, like feathers, stones, or materials. Anything else that catches your eye could be useful in your artwork.

Art box You can collect tools and materials for your work and put them in a box. Sometimes you may need to go to an art store to get exactly what you need, but often you can find things that you can use at home. Ask for something for your art box for your birthday.

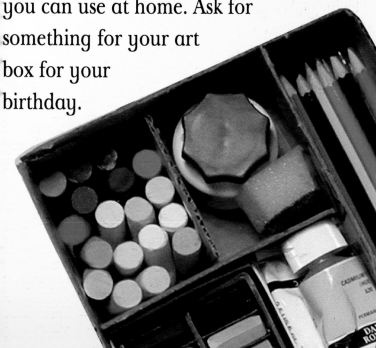

Drawing people

Drawing people is quite difficult, but with help you can get better at it. Remember always to look carefully.

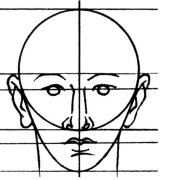

Head shape

Look at the shape and draw the outline. Practice drawing eyes, noses, mouths, and ears in your sketchbook. How will you do the hair?

Face measurements

It helps when drawing a face to divide the head into sections as shown. See how the eyes sit on one line, and the nose on another. Look at where the ears and mouth are.

Body measurements

About six heads fit into a full-length body. So, whatever size you draw the head, measure two more to the waist and three more to the feet.

Always sketch first, and draw in the details afterward.

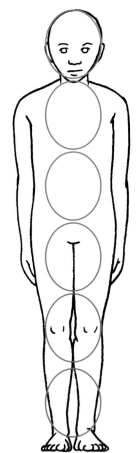

PAINTING ON A SURFACE

Rekhmere was an Egyptian court official. He wanted his tomb full of pictures of his life. What picture would remind you of home? You could paint a picture of your life on clay. Make sure the people are facing sideways.

PROJECT: PAINTING ON A CLAY SURFACE

Step 1. Take a lump of clay and knead it with your hands to make it soft.

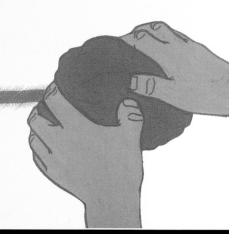

GALLERY

Tomb of Rekhmere, Court Official 15th Century B.C.
THEBES NEW KINGDOM 18TH DYNASTY

MESSAGES
Messages were put on the wall using word pictures, called hieroglyphics, which was Egyptian writing.

SIDE VIEWS
Look at the people facing sideways. This is how Egyptian artists drew people.

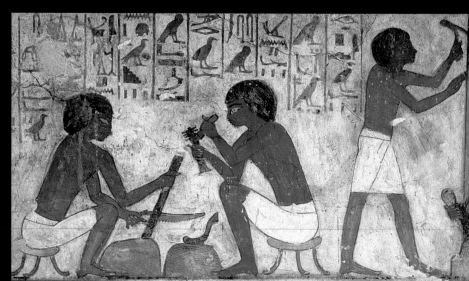

Step 2. Roll out the clay. Don't worry if the edges are not square.

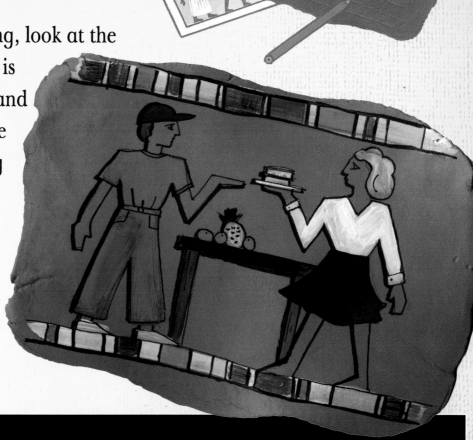

Step 3. While the clay is drying, look at the Egyptian art. When the clay is dry, sketch a picture of you and your family onto it. Make the people face sideways the way they did in Egyptian art.

Step 4. Use paints to color your clay art. You can darken the outlines with felt-tip pen.

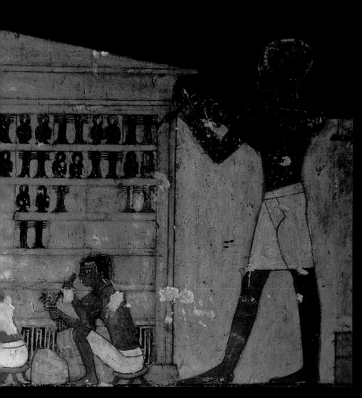

Important ancient Egyptians like Rekhmere used to build their tombs before they died. Artists would paint the walls with wonderful pictures to help make the dead feel at home in the afterlife. This painting shows some craftsmen at work carving wood for Rekhmere.

WORKING IN 3-D

WHAT YOU NEED
Balloon • Tape
Cardboard Tube
Flour • Water
Newspaper
Paintbrush • Paints

Sculpture is three-dimensional, or 3-D, which means that it can be looked at from every side. Do some sketches of a friend like Picasso did. You can use your sketches to help you make a papier-mâché model to look like your friend.

PROJECT: SCULPTURE OF A HEAD

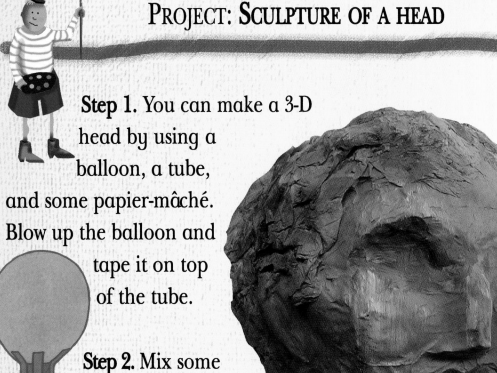

Step 1. You can make a 3-D head by using a balloon, a tube, and some papier-mâché. Blow up the balloon and tape it on top of the tube.

Step 2. Mix some flour and water into a soggy paste. Tear old newspapers into strips, dip them in the paste, and cover the balloon with two layers of paper.

Step 3. Make a nose, eyes, ears, and mouth by crumpling and molding newspaper into shapes and pasting them onto the balloon. Don't forget the hair. Wait for it to dry before you paint it. You could use a bronze color, or bright colors if you prefer.

GALLERY

Head of Dora Maar 1942
PABLO PICASSO (1881 – 1973)

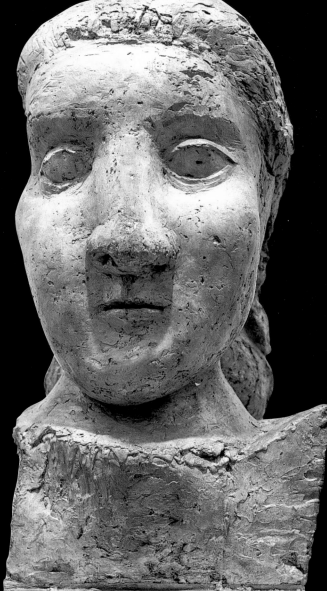

MODELS
Picasso used to ask his friends to sit for him while he drew them and made sculptures of their heads.

SURFACE
Can you see all the different marks on the face and hair, made by the tools Picasso used?

METHOD
Look at the simple lines and shapes Picasso used to make this sculpture of Dora Maar.

MATERIALS
The head was made in clay first to get all the shapes and details right.

The Spanish artist Pablo Picasso changed the way people saw art because he made unusual and very different paintings, drawings, pottery, and sculpture. He did not want his art to look like a photograph. Picasso used his imagination to make art in a way that no one else had ever done.

PATTERN AND COLOR

WHAT YOU NEED
Cardboard • Tape •
Pen Colored Tissue
Paper • Candy
Wrappers
Shiny Paper • Yarn
String • Any Fabrics,
Papers, or Materials

You can make a figure using patterns and colors. Add some gold and silver paper, and paint, and make it in the style of Klimt. It would be fun to cover a life-sized picture in different fabrics, papers, and materials.

PROJECT: A LIFE-SIZED FIGURE

Step 1. Collect pieces of cardboard, and tape them together to make them as long as your friend. Draw around your friend with a pen. Use large pieces of bright-colored tissue paper to decorate the background.

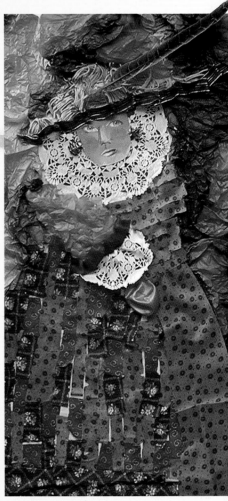

Step 2. Look at Klimt's lovely patterns and shapes and copy some. Glue some candy wrappers or bright fabrics to make the clothes.

Step 3. You can use pictures of faces from magazines for the face. Yarn or string will make good hair.

GALLERY

The Kiss 1908
GUSTAV KLIMT (1862 – 1918)

GOLD
Klimt's father made gold objects. Klimt used to watch him work and liked to make gold an important part of his own artwork.

MODEL
The woman's face looks like the wife of one of Klimt's close friends.

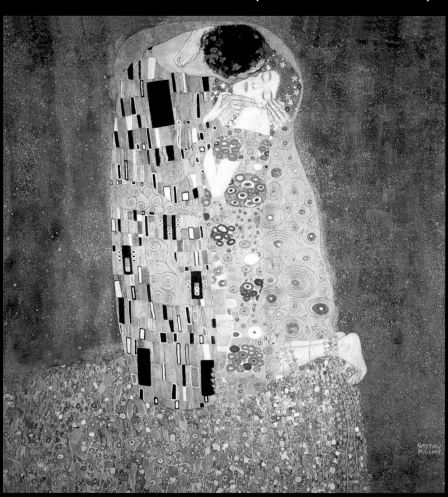

MOSAIC
After seeing mosaics in Italy, Klimt made this carpet of flowers look like a mosaic.

PATTERN
Can you see the different types of pattern on the man's and woman's clothes?

Many people in Austria, where Gustav Klimt lived, thought he was an unusual and interesting artist. He was a big, quiet man who worked hard in his studio from early morning to late evening. All his paintings had a great deal of pattern in them. He used straight lines for men and curved shapes for women. Hands interested him, and he often made them an important part of his pictures.

CARICATURES

Drawing was Monet's best subject at school. He found other schoolwork boring, but drew caricatures of his schoolteachers and friends to amuse them. Caricatures are often drawn of famous people to make fun of them, but you can do yours for enjoyment!

GALLERY

Caricatures c.1855
CLAUDE MONET (1840 – 1926)

CARICATURE
A caricature is made when an artist takes a person's features and exaggerates them.

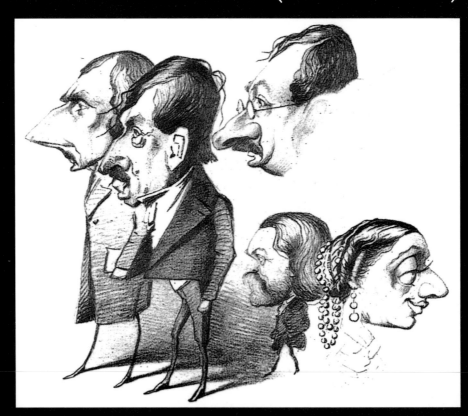

HEAD AND BODY
Sometimes Monet would give his caricature a small body. This would make the head look even more unusual.

PROJECT: DRAWING A CARICATURE

Step 1. Once you have made your sketch or chosen a photograph, look at it carefully and pick out some special features, like the nose, eyes, hairstyle, or chin.

Step 2. Practice enlarging and changing them in your sketchbook so they look amusing (but not unkind!)

Claude Monet always enjoyed drawing when he was at school in France. This is when he started to draw caricatures. He also liked to paint outdoors. He traveled a great deal, always taking his paints with him. Later, Monet became part of a group of French painters called Impressionists. He used paint to capture the way light played on landscapes and buildings.

Step 3. Choose what you are going to exaggerate and then draw the caricature. Can you still tell who it is meant to be? You can add a small body like Monet did if you like.

DRAWING

Can you see how Degas used pastels to show the movement of the dancers and the light sparkling on their costumes? Degas liked to use different drawing materials in his pictures. You can try using different drawing materials and see what they will do.

PROJECT: MATERIALS

Step 1. Collect as many drawing materials and types of paper as possible. Cut the paper into squares. Make a viewfinder by folding a piece of paper into four. Cut out the middle and open it out. Pick a dancer from the picture, frame her in your viewfinder, and trace over her. Copy her on the pieces of paper.

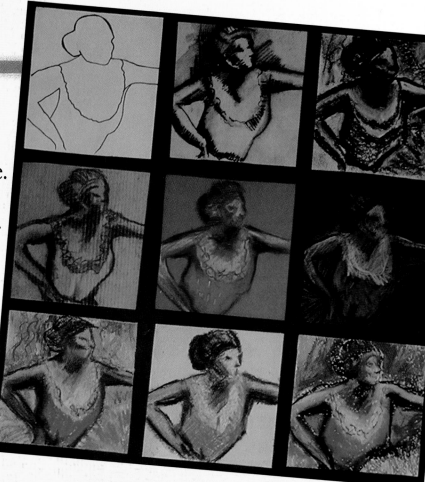

Step 2. Use all your different drawing tools. Which ones make the dancer look most like the one Degas drew? Glue your drawings on a piece of cardboard to display them.

GALLERY

Dancers in Yellow and Green c.1899-1904
EDGAR DEGAS (1834 – 1917)

IMPRESSION
Degas did not show small details on hands and faces. He used pastels to create an impression of them.

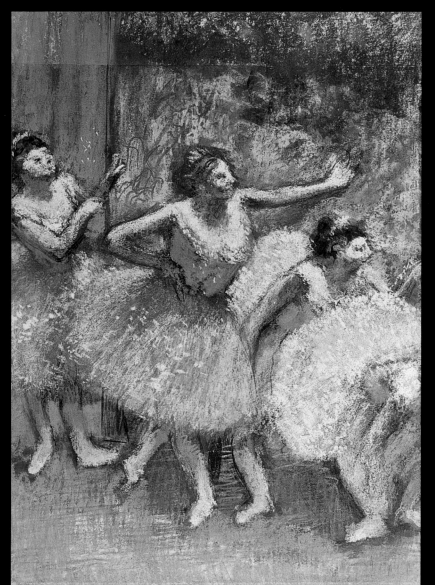

BACKGROUND
Layers of pastels were built up on top of each other to make a lively background. Can you see that some of the marks are like scribbles?

STORY
The dancers are all looking at something out of the picture. Perhaps they are waiting for their turn to go on stage.

DOTS
Dots of yellow make the dancers' costumes come to life and shimmer in the light.

Edgar Degas was born into a rich family in Paris. He studied art in Paris and Italy, and became a very skilled painter. He was one of the first artists to be interested in photography. He looked at people as if he were a camera, drawing them in action rather than posed as for a portrait.

CARVING

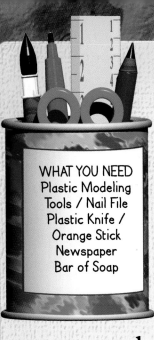

WHAT YOU NEED
Plastic Modeling
Tools / Nail File
Plastic Knife /
Orange Stick
Newspaper
Bar of Soap

Michelangelo used to travel to a quarry to choose pieces of marble for his sculptures. Carvings can be made from many different materials, including soap. It is soft to cut and easy to find at home.

PROJECT: CARVING A SOAP HEAD

Step 1. You will need some plastic modeling tools, but an old nail file, orange stick, or plastic knife will do as well. Work on a piece of newspaper so you do not make too much mess.

Step 3. Add the details like eyebrows, hair, and cheeks. You could make faces of all your family in different colors, and display them in the bathroom!

Step 2. Mark where you will put the eyes, nose, mouth, and hair on the soap, using a pointed tool. Start to carve out the shapes until the soap looks like a face (see tips on page 7).

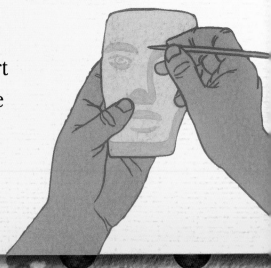

GALLERY

The Madonna of the Stairs 1491–1492
MICHELANGELO BUONARROTI (1475 – 1564)

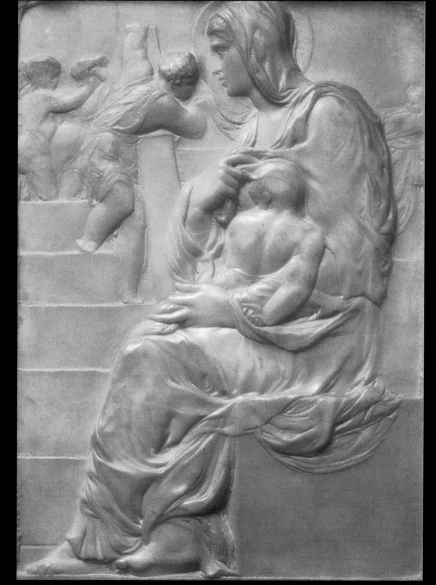

MATERIALS
This picture of the Virgin Mary and her baby Jesus was carved from a slab of marble only 2 inches thick.

YOUNG ARTIST
Michelangelo carved this when he was sixteen. He has made the Virgin Mary and Jesus look like an ordinary mother and baby.

LOW RELIEF
The figures are cut just slightly into the surface of the marble, using a fine chisel. This method of work is called low relief.

CARVING
Although carved out of solid marble, the clothes flow as if they are real.

By the time he was thirteen, Michelangelo had begun to learn to paint and make sculpture. A great deal of his work was for the Christian church and showed scenes from the Bible. His most famous painting is on the ceiling of the Sistine Chapel in Rome, which he painted all by himself.

SELF-PORTRAITS

WHAT YOU NEED
Pencil • Thick Paper
Acrylic Paints
Palette • Brushes
Glue Spreader
Corrugated
Cardboard

Look carefully at Van Gogh's self-portrait, then try out some swirls and lines of your own. Mix the paint thickly and put it on the page using a strip of cardboard or a glue spreader. Get as much texture into your portrait as possible.

PROJECT: TEXTURE

Step 1. Look at yourself in a mirror. Draw your head and shoulders on a piece of cardboard or thick paper.

Step 2. Start painting, using acrylic paint and a variety of tools. Use a glue spreader, corrugated cardboard, and brushes. You can even squeeze the paint straight from the tube! Make the paint really thick.

Step 3. Add swirls of paint in different colors, building up the texture. You can add more detail to your painting once the thick paint has dried a bit. You now have a portrait of yourself in the style of Van Gogh

GALLERY

Self-Portrait 1889
VINCENT VAN GOGH (1853 – 1890)

SHADING
To show light
and dark on
the painting,
Van Gogh used
shades of blue
and green.

COLOR
You can see that a
mixture of blues,
greens, and white
have been used in
this picture. Van
Gogh chose colors
to fit his mood.
How do you
think he was
feeling?

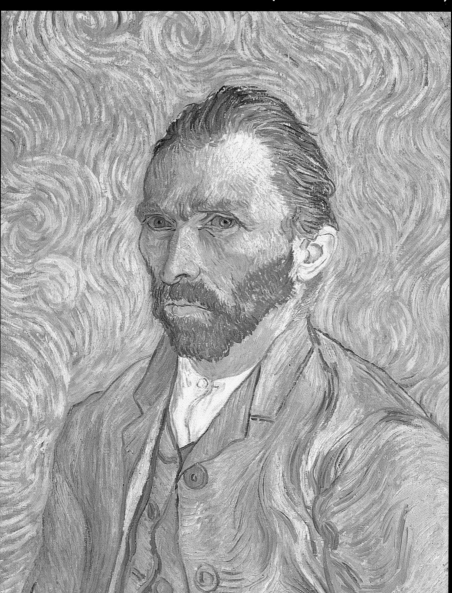

BRUSH STROKES
Look closely at
the background
and you will see
a swirly pattern.
There are also
curved and
straight lines on
Van Gogh's
jacket and face.

THICK PAINT
Van Gogh used
very thick oil
paint. He put
it on the
canvas with
big brush
strokes.

Vincent Van Gogh grew up in Holland but later
lived and worked on his paintings in France. When
he was thirty-six, he painted this portrait of himself
looking like a French farmer. Van Gogh did not
want to paint like anyone else, and nobody
seemed to understand his way of working.

ABSTRACT PORTRAITS

WHAT YOU NEED
Paper • Pens
Pencils • Ruler
Crayons • Chalks
Paints

Paul Klee's painting is abstract rather than realistic. He used geometric shapes like circles, ovals, triangles, rectangles, and squares to make his portrait. You can draw a picture of people you know in the same style.

PROJECT: ARRANGING SHAPES

Step 1. Look at what you are going to draw and decide how you could divide it into geometric shapes. Draw in the body and head shapes as a starting point.

Step 2. Draw in shapes across and around the people. Use curved and straight lines and many different shapes.

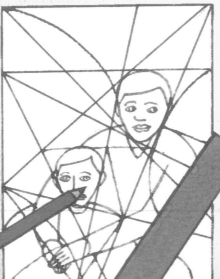

Step 3. Choose some colors that you think will give the portraits life and character.
You can use pencils, crayons, chalks, or paints to color in your drawing.

GALLERY

Senecio 1922
PAUL KLEE (1879 – 1940)

SIMPLE SHAPES
Can you see how this face is made up of simple rectangles, squares, triangles, and circles?

COLOR
Each shape and color is carefully chosen to give the face expression and make it come alive.

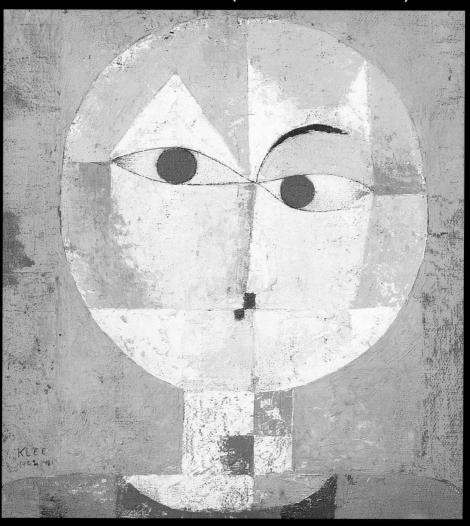

TEXTURE
Klee painted this picture on linen, which is a roughly woven material. You can see the texture of the cloth through the paint.

Paul Klee did not paint like other artists of his day. He liked to work alone and usually did about two hundred pictures a year, each one different from the last. Many of his pictures were made up of shapes and patterns that had a hidden meaning. This portrait is called *Senecio*, which is the name of a group of plants. The title is the clue to help us see that Klee has painted this face to look like the head of a flower.

MAKING A MOSAIC

Look at the colors, patterns, and tones in this mosaic from Ravenna in Italy. It was made by pressing pieces of colored glass, marble, and stone into cement to make a large picture. You can make your own mosaic using paper.

PROJECT: MOSAIC PORTRAIT

Step 1. Find a picture in a magazine or a photo of a friend. Draw an outline of the face on a piece of cardboard.

Step 2. Cut or tear lots of colored scraps of paper from magazines. Choose colors that you can use to create a face, mouth, eyes, nose, and hair. Try to find lots of different tones of the same color.

Step 3. Glue the scraps to the cardboard to build up the face. When it is dry, paint over it with craft glue mixed with water as a varnish.

24

GALLERY

The Empress Theodora with Her Retinue c.547
RAVENNA, ITALY

COLOR
Look at the wonderfully rich colors used for this mosaic. Small pieces of bright glass were the main material used.

MATERIALS
Semiprecious stones were used in the mosaic to make Empress Theodora's beautiful jewelry.

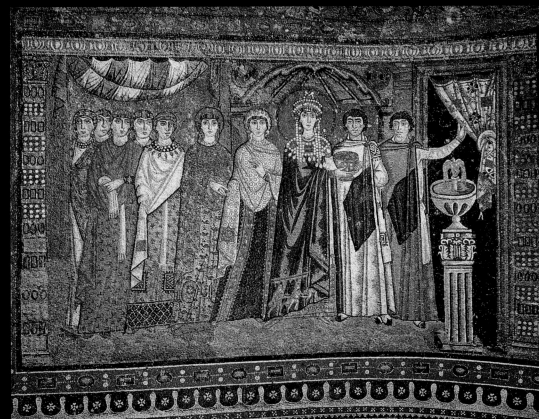

PATTERNS
How many different patterns are there? They show how important she was.

DETAIL
Many pieces were used to create each face. They are so well done that from a distance they look like a painting.

This mosaic is almost fifteen hundred years old. Many churches used mosaics to tell Bible stories. The artist for this mosaic is unknown, but the mosaics in Ravenna are probably the most famous in the world. This one shows the Roman Empress Theodora bringing gifts to the church.

ASSEMBLAGE

Many famous people liked Arcimboldo's portraits so much that they paid him to paint one for them. Arcimboldo's paintings are made by assembling a collection of objects. You can make a strange head using things you have at home.

PROJECT: COLLAGE

Step 1. Collect all kinds of interesting objects like paper clips, thread spools, string, nuts and bolts, hooks, screws, pins, wire, wrappers, and wood. Find a piece of cardboard from an old box. It will need to be thick and fairly big. Glue on some fine string to make the outline of a face and neck.

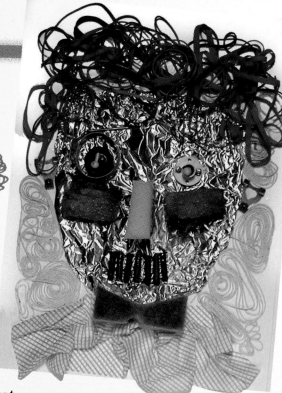

Step 2. Try out different objects you have collected to see which look best as eyes, ears, nose, and mouth. Choose something that would make good hair. When you have made your arrangement, glue it in place and let it dry. You could frame it and invite your friends to see your curious picture.

GALLERY

Vertumnus 1590
GIUSEPPE ARCIMBOLDO (1527 – 1593)

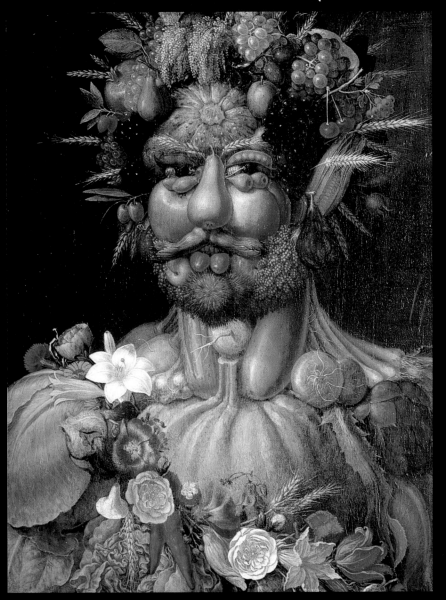

FRUIT
Can you see why each piece of fruit has been chosen? The pear looks like the shape of a nose.

MATERIALS
What would you choose to make a head, eyes, nose, mouth, and hair if you were to make a picture like Arcimboldo's?

DETAIL
Each fruit and flower is painted with great care, showing every detail. Some look good enough to eat.

SUBJECT
Do you find this man's head interesting, friendly, or a bit frightening?

An Italian, born in 1527, Arcimboldo started his work as an artist by making stained-glass windows for churches. He became interested in painting strange and curious people who were considered grotesque. He painted fruit, flowers, trees, and vegetables to create his amazing heads.

USE OF COLOR

WHAT YOU NEED
Paper • Pencil
Tracing Paper
Paints
Paintbrush

Berthe Morisot used cool colors to create a peaceful mood. In your sketchbook, try mixing warm reds, yellows, purples, and oranges as well as cool greens, blues, grays, and lavenders. You can use them to create different moods in your work.

PROJECT: WARM AND COOL COLORS

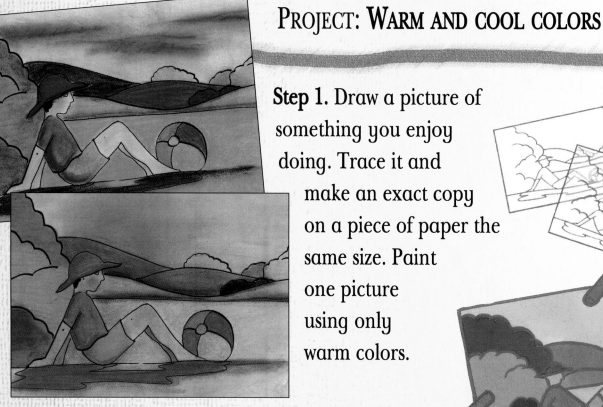

Step 1. Draw a picture of something you enjoy doing. Trace it and make an exact copy on a piece of paper the same size. Paint one picture using only warm colors.

Step 2. Paint the second picture using only cool colors and see how different the two pictures look. How do the colors make you feel? Which one do you prefer?

GALLERY

The Cradle 1872
BERTHE MORISOT (1841 – 1895)

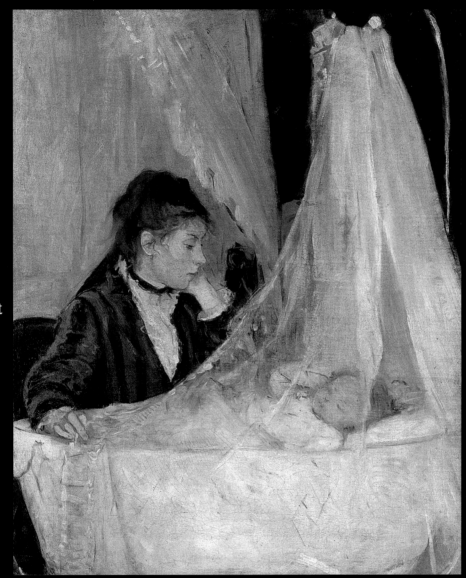

SHADING
The woman is Edma, Berthe's sister. The loving mother with her black hair and dark clothes, quietly looking at her baby asleep, draws your eye toward the baby in the cradle.

COLORS
Most of the colors used by Morisot are cool blues, grays, greens, and whites. They create a sense of peace and quiet, just right for the baby.

LIGHT
The dark background makes the light cradle stand out.

Women were not allowed to study art in college when Berthe Morisot lived in France. Berthe and her sister Edma were determined to learn to paint, so their father allowed them to have lessons. Berthe had a free and easy style, putting the paint on the canvas so you could see the different brush strokes and colors.

IMAGINATION

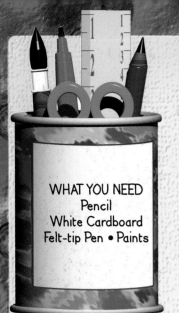

Emmanuel Taiwo Jegede's paintings tell a story about his life and the family and friends he has known in Africa and England. You can make your own picture that tells a story – just let your pencil do the work.

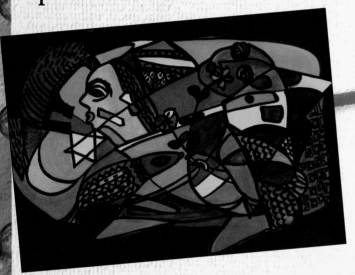

PROJECT: STORYTELLING

Step 1. Use a pencil to make a pattern on a piece of white cardboard. Imagine you are young again and cannot write or draw.

Step 2. Now look at your pattern. Can you see your pet dog, fish, or cat? Can you find a house, tree, or bird shape? Fill in any shapes with a pen.

Step 3. You can follow some of the scribble lines to make more shapes. Use paint or felt-tip pens to fill in the pictures and patterns you have drawn, using lots of bright colors.

Step 4. Use a black felt-tip pen to add patterns to some of the shapes. You now have a picture about you and parts of your life.

GALLERY

Path of Joy 1993
EMMANUEL TAIWO JEGEDE (1943 –)

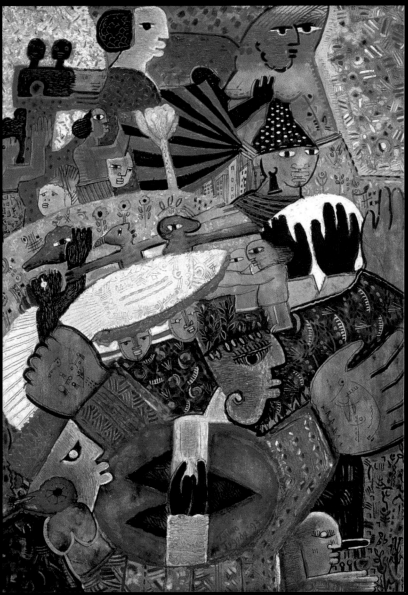

PATTERNS
How many different patterns has Emmanuel used to decorate his picture?

FACES
Can you imagine who all these people are on the Path of Joy? Perhaps they are all the people Emmanuel knows.

COLORS
This is a picture about joy, so the colors Emmanuel has used are bright and cheerful.

HANDS
The hands in the picture are many different colors, showing different people happy together.

In the village in Nigeria, Africa, where Emmanuel Jegede was born, artists are highly regarded. An artist would also write poetry and make music. Jegede studied sculpture and art in Nigeria, but then went to England. He writes beautiful poetry, teaches art to people of all ages, and paints colorful pictures.

GLOSSARY

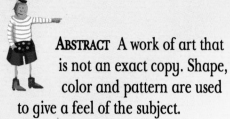

ABSTRACT A work of art that is not an exact copy. Shape, color and pattern are used to give a feel of the subject.

ASSEMBLAGE A work of art made up of a collection of selected objects.

CANVAS Thick cotton or linen fabric stretched over a wooden frame, used instead of paper for painting on.

CARICATURE Comic picture of a person made by drawing exaggerated chin, nose, eyes, hair, and body.

CARVING Making a shape, pattern, or design out of material like wood or stone by cutting with a sharp tool.

COLLAGE Placing different materials on a backing to make a pattern or picture.

GROTESQUE A face or design that is made to look comically strange.

IMPRESSIONISTS A group of French artists who painted the first impression of what they were looking at.

MARBLE Hard rock that comes in many patterns and colors and can be cut, carved, and polished.

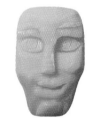

MOSAIC A picture made on a wall or floor by pressing glass and stones into cement.

PORTRAIT A picture of a person or people that can be made using any materials.

RELIEF A carving made on the surface of a piece of rock, stone, or wood.

SCULPTURE Making shapes from hard or soft materials, to make a person, animal, or design that can be looked at from all sides.

SHADE A darker or lighter tone of the same color used to make a picture have more depth.

INDEX

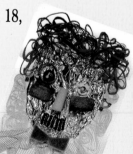